GINNY MACK CRAFTS

PATCHWORK
PATCHES

AuthorHouse™ LLC
1663 Liberty Drive
Bloomington, IN 47403
www.authorhouse.com
Phone: 1-800-839-8640

Published by AuthorHouse 08/29/2014

ISBN: 978-1-4969-3365-2 (sc)
ISBN: 978-1-4969-3366-9 (e)

Library of Congress Control Number: 2014915635

This book is printed on acid-free paper.

authorHOUSE®

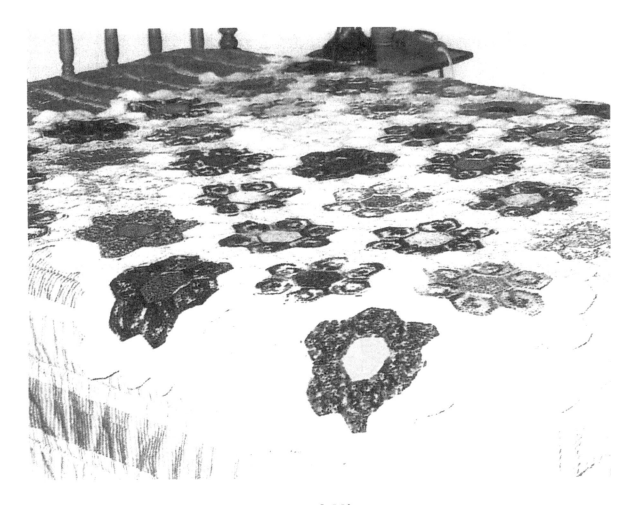

Personal History

I Started sewing at about the age of 6. From there I went on to knitting, crocheting, quilting and more. If it could be made, I found a way to make it. The first object was making a doll clothes for my twin sisters. From there I went to making clothes for myself, my sisters, then later for my daughter. I have been a crafter all my life. This book is my chance to give others a way to make things for themselves and for others.

PATTERN INDEX I

GENERAL INSTRUCTIONS

Ch	Chain
Sc	Single Crochet
Hdc	Half Double Crochet
Dc	Double Crochet
Tro	Triple Crochet
Beg	Beginning
Dec	Decrease
Inc	Increase
Rnd	Round
Tog	Together
Sk	Skip
Sl St	Slip Stich

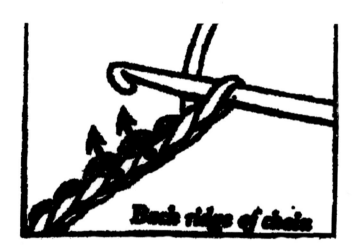

Back ridge of chain

Beg Ch – Unless otherwise Stated in directions work in back single loop of Ch. Gives a neat, smooth look to finished article.

2 – Joined, 3 – Joined Sc – Draw up 2 loops of 2 Sts or 3 loops of 3 Sts and yarn over book and raw through all loops of' book. Decrease made.

Increases are made by working 2 or 3 Sts in one St as directions state.

Working over bar of Stitch – Insert hook under vertical bar of Sc, draw up thread, complete as instructed. Used as a turning row.

Patchwork – Starting colors on foundation Ch make Ch required number of Sts according to pattern, work the first square of' color in chain color ..

Joining New Color – With two loops of 1st colon on hook, bring first color to front of work, hold 2nd color through 2 loops on hook, complete required number of Sts for square, repeat for remaining colors.

Instructions are written for single color, each pattern will have Stitch and row numbers for patchwork designs.

A **pattern** for a bobbin large enough to hold one 100 yard ball is given here. Purchased bobbins for bulky yarn will work.

Changing colors on Trc casing Rnd – Work required number of STS for square, draw loop of new color through St of last row, picking up both colors work Trc to last loop, bring 1St color to front of work, complete at with 2nd color. This carries colors to top of row ready for next color change on next row.

TRIANGLE

With thread yarn and hook of choice:

Rnd 1: Ch 2, 6 Sc in first Ch St, join. 6 Sts

Rnd 2: Ch 1 turn (optional),

*2 Sc in each St around, join. 12 Sts

Rnd 3: Ch 1, turn (opt),

*1 Sc in next 2 Sts, 1Hdc in ext St,

 Ch1, mark for Corner St,

 1Sc in next 2 Sts,

 Repeat from *around, join. 15 Sts

Rnd 4: Ch 1, turn (opt),

*1 Sc in next 2 Sts, 1 Hdc in ext St,

 1 Dc in Ch1 Corner St, carry marker,

 1Hdc in next St, 1Sc in next St,

 Repeat from *around, join. 15 Sts

Rnd 5: Ch 1, turn (opt),

*1Sc in next St, 1Hdc in next St,

1Hdc, 1Dc, mark Corner St,

1Hdc in next St, 1 Sc in next St,

Repeat from* around, join. 15 Sts

Rnd 6: Ch 1, turn (opt),

*1Sc in each St to St before Corner St,

1Hdc in next St,

1Dc in Corner St, carry marker,

1Hdc in next St,

Repeat from around, join. Even Rnd

Rnd 7: Ch 1, turn (opt),

*1Sc in each St to St before Corner St,

1 Sc, 1Hdc in next St,

1Hdc, 1Dc, carry marker, 1Hdc in Corner St,

1Hdc, 1Sc in next St,

Repeat from around, join.12 Rnd Incs

Rnd 8: Ch 1, turn (opt),

*1Sc in each St to St before Corner St,

1Hdc in next St,

1Dc in Corner St, carry marker,

1Hdc in next St,

Repeat from * around, join. Even Rnd

Repeat Rnds 7 and 8 until desired Rnds have been completed.

Rnd #	6	8	10	12	14	16	18	20
Section Sts	6	10	14	18	22	26	30	34
Full Rnd #	21	33	45	57	69	81	93	105
Inches	3"	4"	5"	6"	7"	8"	9"	1 0"

Break off, weave in loose ends.

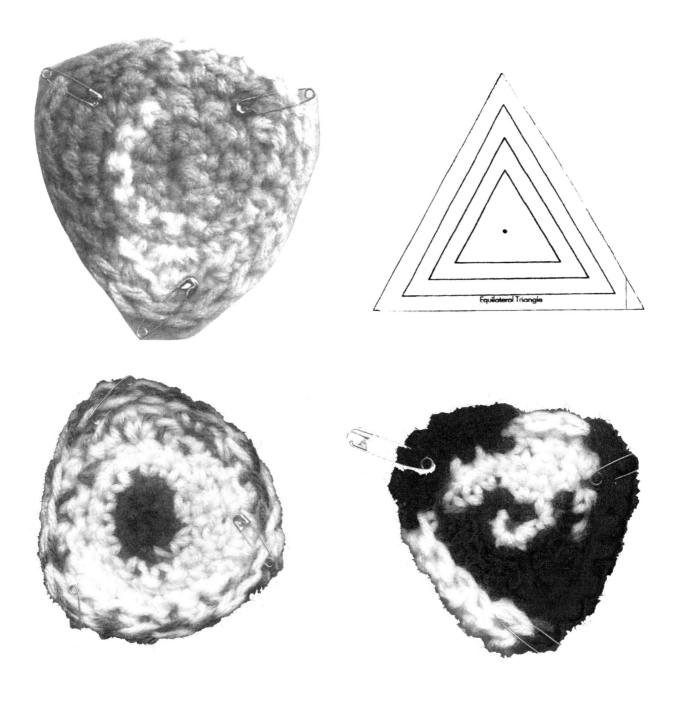

Equilateral Triangle

OCTAGON

With thread yarn and hook of choice:

Rnd 1: Ch 2, 8 Sc in first Ch St, join. 8 Sts

Rnd 2: Ch 1, turn (optional),

 2 Sc in each St around, join. 16 Sts

Rnd 3: Ch 1, turn (opt),

 * 1Sc in next St, 2Sc in next St,

 Repeat from * around, join. 24 Sts

Rnd 4: Ch 1, turn (opt),

 *1Sc in next St,

 1 Hdc in next St, mark Corner St,

 1Sc in next St,

 Repeat from * around, join. 24 Sts

Rnd 5: Ch 1, turn (opt),

 *1Sc in each at to St before Corner St,

 2Sc in next St,

 1 Hdc in Corner St, carry marker,

 2Sc in next St,

 Repeat from * around, join. 16 Rnd incs

Rnd 6: Ch 1, Turn (opt),

 *1Sc in each St to Corner St,

 1Hdc in Corner St, carry marker,

 Repeat from * around, join. Even rnd

Repeat Rnds 5 and 6 until desired Rnds have been completed.

Rnd #	8	10	12	14	16	18	20
Section Sts	6	8	10	12	14	16	18
Full Rnd #	40	56	72	88	104	120	126
Inches	4"	S"	6"	7"	8"	10"	12"

Break off, weave in loose ends.

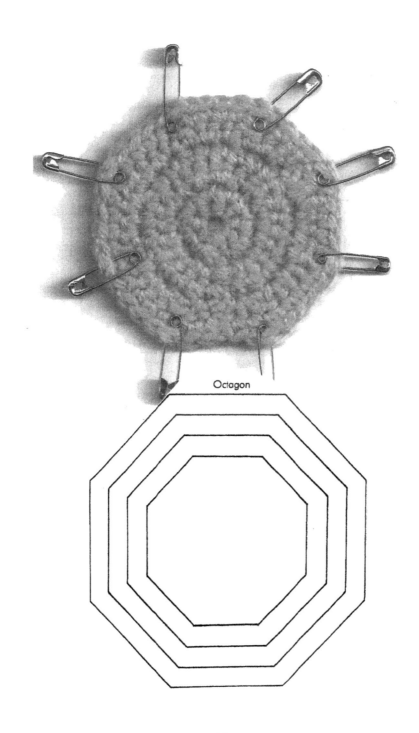

Octagon

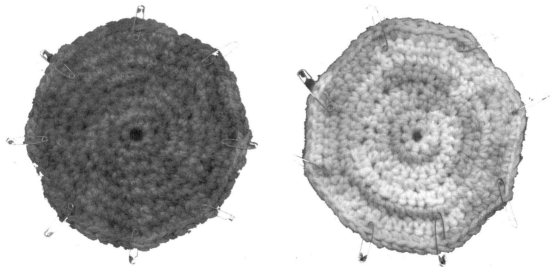

SQUARE

With thread yarn and hook of choice:

Rnd 1: Ch 2, 8 Sc in first Ch St, join. 8 Sts

Rnd 2: Ch 1, turn (optional),

 2 Sc in each St around, join. 16 Sts

Rnd 3: Ch 1, turn (opt),

 *2 Sc in next St,

 1 Cc in next 3 Sts,

 Repeat from * around, join. 20 Sts

Rnd 4: Ch 1, turn (opt),

 *1 Sc in next 2 Sts,

 1 Hdc in next St, carry marker,

 1 Sc in next 2 Sts,

 Repeat from around, join. 20 Sts

Rnd 5: C*h11, turn (opt),

 *1 SC I each St to St before Corner St,

 2Sc in next St,

 1 Hdc in Corner St, carry marker,

 2 Sc in next St,

 Repeat from around, join. 8 Rnd incs

Rnd 6: Ch 1, turn (opt),

 *1 Sc in each St to Corner St,

 1 Hdc in Corner St, carry marker,

 Repeat from * around, join. Even Rnd.

Repeat rnds 5 and 6 until desired rnds have been completed.

Rnd #	6	8	10	12	14	16	18	20
Section Sts	6	8	10	12	14	16	18	20
Full Rnd #	28	36	44	52	60	68	76	84
Inches	3"	4"	5"	6"	7"	8"	9"	10"

Break off, weave in loose ends.

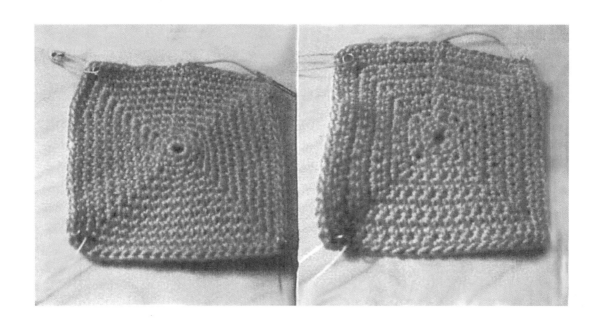

Square

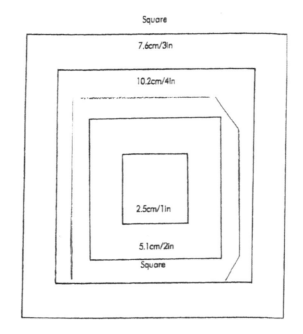

7.6cm/3In

10.2cm/4In

2.5cm/1in

5.1cm/2in

Square

PENTAGON

With thread yarn and hook of choice:

Rnd 1: Ch 2, 5 Sc in first Ch St, join. 5 Sts

Rnd 2: Ch 1, turn (optional),

 2 Sc in each St around, join. 10 Sts

Rnd 3: Ch 1, turn (opt),

 1 Sc in next St,

 Ch 1, mark for Corner St,

 *1 Sc in next 2 Sts,

 Ch 1, mark for Corner St,

 Repeat from * 4 times,

 1 Sc in last St, join. 15 Sts

Rnd 4: Ch 1, turn (opt),

 * 1 Sc in each St to Ch 1 Corner St,

 1 Sc, 1 Hdc, mark, 1 Sc in Corner St,

 Repeat from * around, join. 25 Sts

Rnd 5: Ch 1, turn (opt),

 * 1Sc in each St to St before Corner

 2 Sc in next St,

 1 Hdc in Corner St, carry marker,

 2 Sc in next St,

 Repeat from * around, join. 10 Inc STS 35 Sts

Rnd 6: Ch 1, turn (opt),

 *1 Sc in each St to Corner St,

 1 Hdc in Corner St, carry marker,

 Repeat from around, join. Even Rnd

Repeat rnds 5 and 6 until desired rnds have been completed.

Round #	6	8	10	12	14	16	18	20
Section	6	8	10	12	14	16	18	20
Rnd Sts	35	45	55	65	75	85	95	105
Inches	3"	4"	5"	6"	7"	8"	10"	12"

Break oft, weave in loose ends.

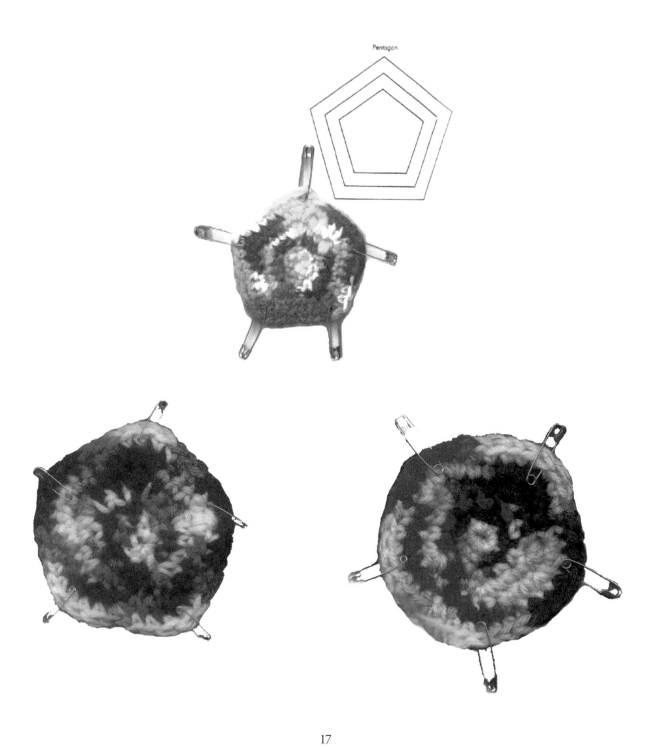

Pentagon

HEXAGON

With thread yarn and hook of choice:

Rnd 1: Ch 2, 6 Sc in first Ch St, join. 6 Sts

Rnd 2: Ch 1, turn (optional),

 2 Sc in each St around, join. 12 Sts

Rnd 3: Ch 1, turn (opt),

 * 1 Sc in next St,

 2 Sc in next St,

 Repeat from * around, join. 18 Sts

Rnd 4: Ch 1, turn (opt)

 *2 Sc in next St,

 1 Hdc in next St, mark Corner St,

 2 Sc in next St, repeat from * around, join. 30 STS

Rnd 5: Ch 1, turn (opt),

 * 1 Sc in each St to St before Corner St,

 2 Sc in next St,

 1 Hdc in Corner St, carry marker,

 2 Sc in next St, repeat from * around, join. 12 incs

Rnd 6: Ch 1, turn (opt),

 * 1 Sc in each St to Corner St,

 1 Hdc in Corner St, carry marker,

 Repeat from* around, join. Even rnd

Repeat rnds 5 and 6 until desired rnds have been completed.

Rnd #	6	8	10	12	14	16	18	20
Section	6	8	10	12	14	16	18	20
Rnd Sts	42	54	66	78	90	102	114	126
Inches	3"	4"	S"	6"	7"	8"	10"	12"

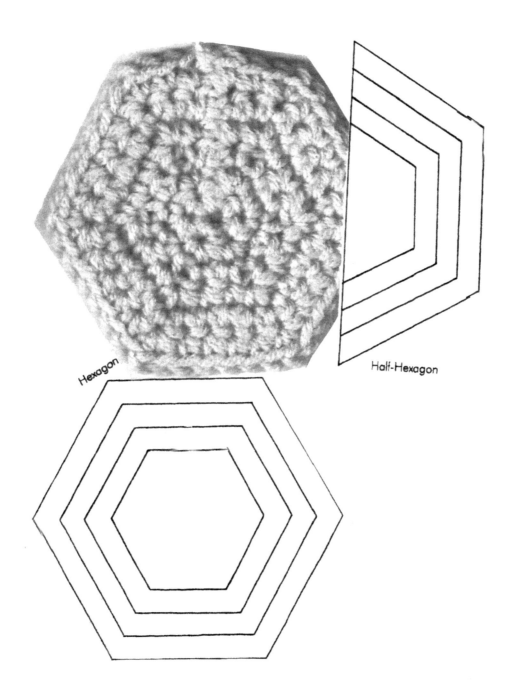

Hexagon

Half-Hexagon

DIAMOND

With thread yarn and hook of choice:

Rnd 1: Ch 7, work in single back loop of Ch,

 2 Sc in 2nd St from hook,

 1 Sc in next 2 Sts,

 Ch 1, mark for Corner St,

 1 Sc in next 2 Sts,

 2 Sc in first Ch St,

 Ch 1, mark for Point St,

 2 Sc in first Ch St,

 1 Sc in next 2 Sts,

 Ch 1, mark for Corner Sc

 1 Sc in next 2 Sts,

 2 Sc in last St,

 Join. 19 Rnd Sts

Rnd 2: Ch 1, turn (optional),

 1 Hdc11Sc in first Point St,

 1 Sc in next 3 Sts,

 1 Hdc in Corner St, carry marker,

 1 Sc in next 4 Sts,

 1 Hdc, 1 Dc, mark, 1 Hdc in Point St,

 1 Sc in next 4 Sts,

 1 Hdc in Corner St, carry marker,

1 Sc in next 3 Sts,

1 Sc, 1 Hdc in last Point St,

Join. 23 Rnd Sts

Rnd 3: Ch 3, turn (opt),

1 Dc, 1 Hdc in first Point St,

1 Hdc, 1 Sc in next St,

1 Sc in each St to St before Corner St,

1 Hdc in next St,

1 Dc in Corner St, carry marker,

1 Hdc in next St,

1 Sc in each St to 2 Sts before Point St,

1 Sc, 1 Hdc in next St,

1 Hdc, 1 Dc in next St,

1 Dc in Point St, carry marker,

1 Dc, 1 Hdc in next St,

1 Hdc, 1Sc in next St,

1 Sc in each St to St before Corner St,

1 Hdc in next St,

1 Dc in Corner St, carry marker,

1 Sc in each St to last 2 Sts,

1 Sc, 1 Hdc in next St,

1 Hdc, 1 Dc in last Point St,

Join in top of Ch3. 16 Rnd Sts

Rnd 4: Ch 3, turn (opt),

 1 Dc in first Point St, *,

 1hdc in next 2 Sts,

 1 Sc in each St to St before Corner St,

 1 Hdc in next St,

 1 Dc in Corner St, carry marker,

 1 Hfc in next St,

 1 Sc in each St to 2 Sts before Point St,

 1 Hdc in next 2 Sts,*,

 1 Dc in Point St, carry marker,

 Repeat between *'s once,

 Join in top of Ch 3. Even rnd.

Repeat rnds 3 and 4 until desired rnds have been completed.

Rnd #	6	8	10	12	14	16	18	20
Section Sts	7	11	13	15	17	19	21	23
Rnd Sts	32	48	56	64	72	80	88	96
Inches	3-7	4-8	5-9	6-10	7-11	8-12	9-14	10-14

Measurements are approximate.

Break off, weave in loose ends.

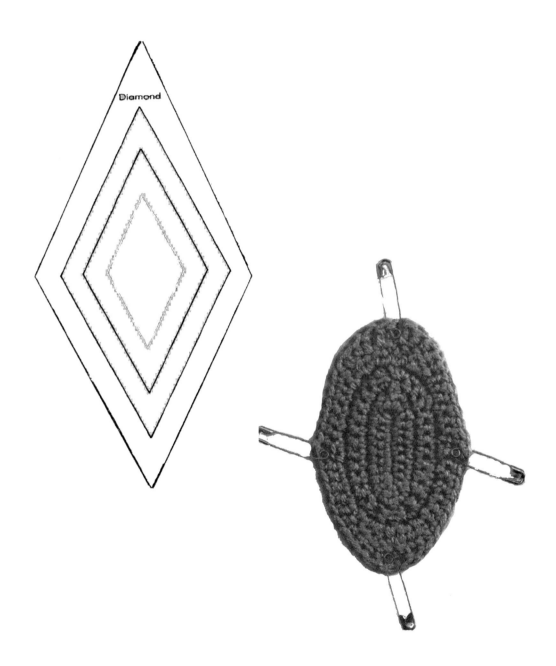

Diamond

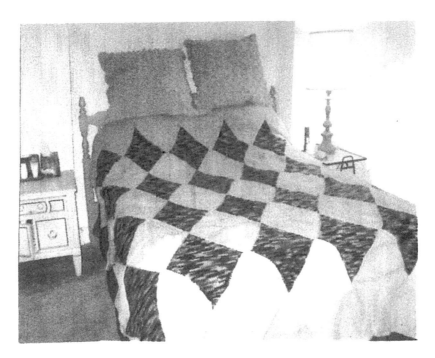

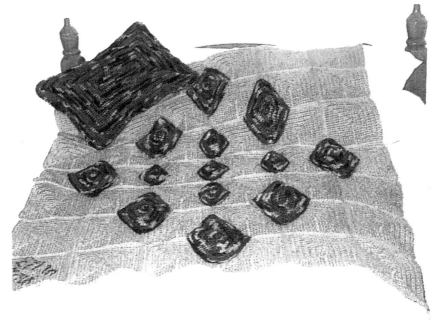

RECTANGLE

With thread yarn and hook of choice:

Rnd 1: Ch.___, 15 - 21 - 27 - 33 - 39 - 45

 1 Sc in 2nd St from hook,

 1 Hdc in next St, mark for Corner St,

 1 Sc in next Sts, 10 – 16 – 22 – 28 – 34 - 40

 1 Hdc in next St, mark for Corner St,

 2 Sc in first Ch St,

 Working around Ch in double front loop,

 1 Sdc in next St, mark for Corner St,

 1 Sc in next Sts, 10 – 16 – 22 – 28 – 34 - 40

 1 Hdc in next St, mark for Corner St,

 1 Sc in last St,

 Join. Rnd Sts 26 – 38 – 50 – 62 – 74 - 86

Rnd 2: Ch 1, turn {optional),

 *1 Sc in next St,

 1 Hdc in Corner St, carry marker,

 2 Sc in next St,

 1 Sc in next St, 8 – 14 – 20 – 27 – 30 - 38

 2 Sc in next St,

 1 Hdc in Corner St, carry marker,

 1 Sc in next St,

 Repeat from * around,

Join. Rnd STS 30 – 42 – 54 – 66 – 78 – 90

Rnd 3: Ch 1, turn (opt),

* 1 Sc in next St,

1 Hdcin Corner St, carry marker,

2 Sc in next St,

1 Sc in each St to St before Corner St,

2 Sc in next St,

1 Hdc in Corner St, carry marker,

1 Sc in next St, *,

Repeat between *'s around,

Join. Rnd Sts 34 – 46 – 58 – 70 – 82 - 94

Rnd 4: Ch 1, turn (opt),

*2 Sc in next St,

1 Hdc in Corner St, carry marker,

1 Sc in each St to Corner St,

1 Hdc in Corner St, carry marker,

2 Sc in next St, *

Repeat between 8's around,

Join. Rnd Sts 38-50-62-74-86-98

Rnd 5: Ch 1, turn (opt),

* 1 Sc in each St to St before Corner St,

2 Sc in next St,

1 Hdc in Corner St, carry marker,

2 Sc in next St '*

Repeat between *'s around,

Join. 8 rnd incs. 46 – 58 – 70 – 82 – 94 - 106

Rnd 6: Ch 1, turn (opt),

*1 Sc in each St to Corner St,

1 Hdc in Corner St, carry marker,

Repeat from * around, join. Even rnd

Repeat rnds 5 and 6 until desired rnds have been completed.

Rnd #	6	8	10	12	14	16
Squares	2	3	4	5	6	7
Rnd Sts	46	58	70	82	94	106

Break off, weave in loose ends.

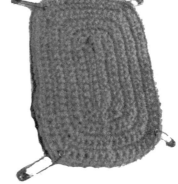

OVAL

With thread yarn and hook of choice:

Rnd 1: Ch___, 15 21 27 33 39 45

 Begin work on single back loop Oc Ch,

 2 Sc in 2nd St from hook,

 1 Sc in each St to first Ch St,

 3 Sc in first Ch St,

 Mark 2nd St Center St,

 Working in double loop of Ch,

 1 Sc in each St to last Ch St,

 2 Sc in last St, join.

 Rnd Sts 32 44 56 68 80 96

Rnd 2: Ch 1, turn (optional),

 *2 Sc in next 2 Sts,

 1 Sc in each St to 2 Sts before Center St,

 2 Sc in next 2 Sts *,

 1 Sc in Center St, carry marker, repeat between *'s around, join.

 Rnd STS 40 – 52 – 64 – 76 – 88 - 104

Rnd 3: Ch 1, turn (opt),

 *[1 Sc in next St, 2 Sc in next St] 3times

 1 Sc in each St to 6 Sts before Center St, [2 Sc in next St, 1 Sc in next St] 3 times,

 *1 Sc in Center St, carry marker,

 Repeat between *'s around, join.

| Rnd STS | 52 | 64 | 76 | 88 | 100 | 112 |

Rnd 4: Ch 1, turn (opt),

 1 Sc in each St around, carry markers,

 Join. Even rnd

Rnd 5: Ch 1, turn (opt),

 *[1 Sc in next 2 Sts, 2 Sc in next St] 3 times,

 1 Sc in each St to last 9 Sts before Center St,

 [2 Sc in next St, 1 Sc in next 2 Sts] 3 times, *,

 1 Sc in Center St, carry marker, repeat between *'s around, join.

 12 rnd incs.

Rnd 6: Ch 1, turn (opt),

 1 Sc in each St around, carry marker,

 Join. Even rnd.

Repeat rnds 5 and 6, inc 1 St between inc Sts, in rnd 5, until desired rnds have been completed.

Rnd #	6	8	10	12	14	16
Rnd Sts	64	76	88	100	112	124
Inches	6"	7"	8"	12"	14"	16"

Break off, weave in loose ends.

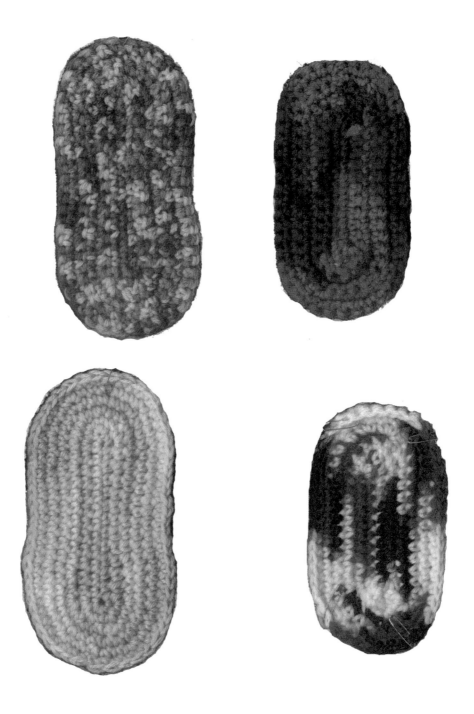

34

CIRCLE

With thread yarn and hook of choice:

Rnd 1: Ch 2, 8 Sc in first St of Ch, join. 8 Sts

Rnd 2: Ch 1, turn (optional),

 2 Sc in each St around, join. 16 Sts

Rnd 3: Ch 1, turn (opt)

 *1 Sc in next St,

 2 Sc in next St,

 Repeat from around, join. 24 Sts

Rnd 4: Ch 1, turn (opt),

 1 Sc in each St around, join. 24 Sts

Rnd: Repeat rnd 3, 36 Sts

Rnd 6: Repeat rnd 4.

Rnd 7: Ch 1, turn (opt),

 * 1 Sc in next 2 Sts,

 2 Sc in next St,

 Repeat from around, join. 48 Sts

Rnd 8: Repeat rnd 4. Rnd 9: Ch 1, turn (opt),

 *1 Sc in next 3 Sts,

 2 Sc in next St,

 Repeat from * around, join. 48 Sts

Rnd 10: Ch1, turn (opt), 36 Sts

 1 Sc in each 48 Sts around, join. 60 Sts

Rnd 11: Ch 1, turn (opt),

 *1 Sc in next 4 Sts,

 2 Sc in next St,

 Repeat from * around, join. 72 Sts

Rnd 12: Repeat rnd 10. 72 Sts

Rnd 13: Ch 1, turn (opt),

 *1 Sc in next 5 Sts,

 2 Sc in next St,

 Repeat from * around, join. 84 Sts

Rnd 14: Repeat rnd 10. 84 Sts

Rnd 15: Ch 1, turn (opt),

 *1 Sc in next 6 Sts,

 2 Sc in next St,

 Repeat from * around, join. 96 Sts

Rnd 16: Repeat rnd 10. 96 Sts

Rnd 17: Ch 1, turn (opt),

 *1 Sc in next 7 Sts,

 2 Sc in next St,

 Repeat from * around, join. 108 Sts

Rnd 18: Repeat rnd 10. 108 Sts

Rnd 19: Ch 1, turn (opt),

 *1 Sc in next 8 Sts,

 2 Sc in next St,

 Repeat from * around, join. 120 St

Rnd 20: Repeat rnd 10. 120 St

Repeat rnds 11 thru 20 until desired size have been completed.

Rnd #	8	18	12	14	16	18	20	
Rnd Sts	36	48	60	72	84	96	108	120
Inches	3"	4"	5"	6"	8"	10"	12"	14"

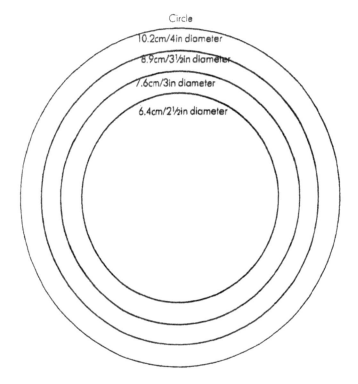

Circle

10.2cm/4in diameter

8.9cm/3½in diameter

7.6cm/3in diameter

6.4cm/2½in diameter

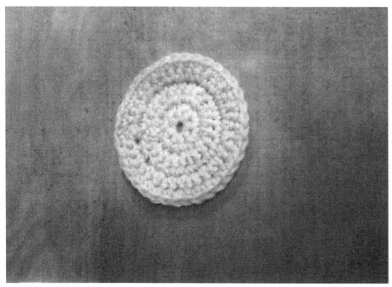

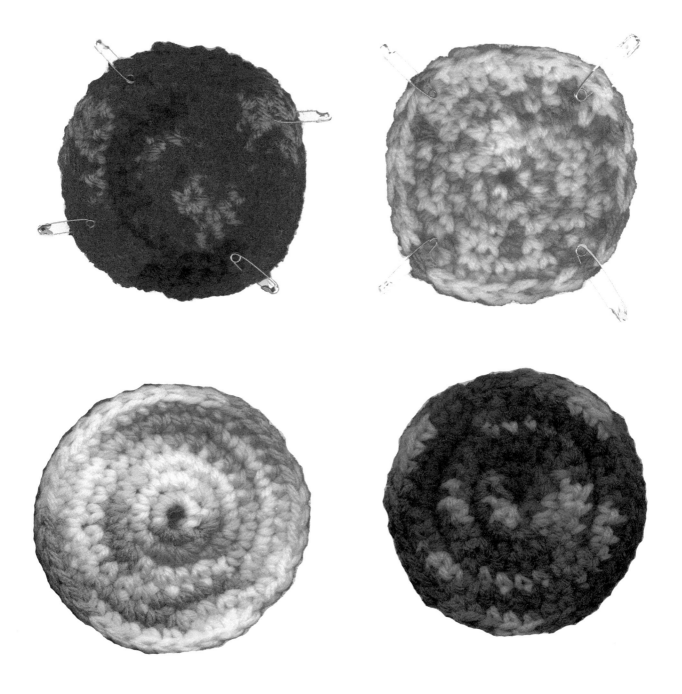

HALF CIRCLE

With yarn and hook of choice:

Row 1: Ch 3,

 2 Sc in 2nd St from hook,

 3 Sc in first Ch St, mark 2nd St Center St,

 2 Sc in back double St of first Ch St. 7 Sts

Row 2: Ch 1,

 1 Sc in first 3 Sts,

 3 Sc in Center St, carry marker,

 1 Sc in last 3 Sts. 9 Sts

Row 3: Ch 1, turn,

 1 Sc in first 2 Sts,

 2 Sc in next 2 Sts,

 1 Sc in Center St, carry marker,

 2 Sc in next 2 Sts,

 1 Sc in last 2 Sts. 13 Sts

Row 4: Ch 1, turn,

 1 Sc in each St across row, carry marker

Row 5: Ch 1, turn,

 1 Sc in first 3 Sts,

 2 Sc in next 3 Sts,

 1 Sc in Center St, carry marker,

 2 Sc in next 3 Sts,

1 Sc in last 3 Sts. 19 Sts

Row s: Ch 1, turn,

 1 Sc in each St across row, carry marker

Row 7: Ch 1, turn,

 1 Sc in first St,

 2 Sc in next St,

 1 Sc in next 7 Sts,

 1 Sc in Center St, carry marker,

 1 Sc in next 7 Sts,

 2 Sc in next St,

 1 Sc in last St. 21 Sts

Rnd 8: Ch, turn,

 1 Sc in each St across row, carry marker

Row 9: Ch 1, turn,

 1 Sc in first 4 Sts,

 2 Sc in next 6 Sts,

 1 Sc in Center Sts, carry marker,

 2 Sc in next 6 Sts,

 1 Sc in last 4 Sts. 33 Sts

Rows 10-11-12: Ch 1, turn,

 1 Sc in each St across row, carry marker

Row 13: Ch 1, turn,

 1 Sc in first 4 Sts,

 *2 Sc in next St, 1 Sc in next St, repeat from * 6 times,

1 Sc in Center St, carry marker,

*Sc in next St, 2 v in next St, repeat from * 6 times,

1 Sc in last 4 Sts. 45 Sts

Rows 14-15-16: Ch 1, turn,

1 Sc in each St across row,

Carry marker.

Row 17: Ch 1, turn,

1 Sc in first 10 Sts,

*2 Sc in next St, 1 Sc in next St,

Repeat from * 6 times,

1 Sc in Center St, carry marker,

* Sc in next St, 2 v in next St, repeat from * 6 times,

1 Sc in last 10 Sts. 57 Sts

Rows 18-19-20: Ch 1, turn,

1 Sc in each St across row,

Carry marker.

Row 21: Ch 1, turn,

1 Sc in first 10 Sts,

*2 Sc in next St,

1 Sc in next 2 Sts, repeat from * 6 times,

1 Sc in Center St, carry marker,

*1 Sc in next 2 Sts,

2 Sc in next St,

Repeat from * 6 times,

1 Sc in last 10 Sts. 69 Sts

Row 22-23-24: Ch 1 turn,

 1 Sc in each St across row,

 Carry marker.

Row 25: Ch 1, turn,

 1 Sc in first 16 Sts,

 *2 Sc in next St,

 1 Sc in next 2 Sts, repeat from * 6 times,

 1 Sc in Center St, carry marker,

 *1 Sc in next 2 Sts,

 2 Sc in next St,

 Repeat from * 6 times,

 1 Sc in last 16 Sts. 81 Sts

Row 26-27-28: Ch 1, turn,

 1 Sc in each St across row,

 Carry marker.

Row 29: Ch 1, turn,

 1 Sc in first 16 Sts,

 *2 Sc in next St,

 1 Sc in next 3 Sts, repeat from * 6 times,

 1 Sc in Center St, carry marker,

 *1 Sc in next 3 Sts,

 2 Sc in next St,

 Repeat from * 6 times,

43

1 Sc in last 16 Sts. 93 Sts

Row 30-31-32: Ch 1, turn,

 1 Sc in each St across row,

 Carry marker.

Row 33: Ch 1, turn,

 1 Sc in next 22 Sts,

 * 2 Sc in next St,

 1 Sc in next 3 Sts, repeat from * 6 times,

 1 Sc in Center St, carry marker,

 * 1 Sc in next 3 Sts,

 2 Sc in next St,

 Repeat from * 6 times,

 1 Sc in last 22 Sts. 105 St

Rows 34-35-36: Ch 1, turn,

 1 Sc in each St across row,

 Carry marker.

Row 37: Ch 1, turn,

 1 Sc in first 22 Sts,

 * 2 Sc in next St,

 1 Sc in next 4 Sts, repeat from * 6 times,

 1 Sc in Center St, carry marker,

 * 1 Sc in next 4 Sts,

 2 Sc in next St,

 Repeat from * 6 times,

1 Sc in last 22 Sts. 117 St

Rows 38-39-40: Ch 1, turn,

 1 Sc in each St across row,

 Carry marker.

Row 41: Ch 1, turn,

 1 Sc in first 28 Sts,

 * 2 Sc in next St,

 1 Sc in next 4 Sts,

 Repeat from 6 times,

 1 Sc in Center St, carry marker,

 * 1 Sc in next 4 Sts,

 2 Sc in next St,

 Repeat from * 6 times,

 1 Sc in last 28 Sts. 129 St

Rows 42-43-44: Ch 1, turn,

 1 Sc in each St across row,

 Carry marker.

Row 45: Ch 1, turn,

 1 Sc in first 28 Sts,

 * 2 Sc in next St,

 1 Sc in next 2 Sts, repeat from * 6 times,

 1 Sc in Center St, carry marker,

 * 1 Sc in next 2 Sts,

 2 Sc in next St,

Repeat from * 6 times,

 1 Sc in last 28 Sts. 141 Sts

Rows 46-47-48: Ch 1, turn,

 1 Sc in each St across row,

 Carry marker.

Row 49: Ch 1, turn,

 1 Sc in first 28 Sts,

 * 2 Sc in next St,

 1 Sc in next 3 Sts, repeat from * 6 times,

 1 Sc in Center St, carry marker,

 * 1 Sc in next 3 Sts,

 2 Sc in next ST,

 Repeat from * 6 times,

 1 Sc in last 28 Sts. 153 Sts

Rows 50-51-52: Ch 1, turn

 1 Sc in each St across row,

 Carry marker.

Row 53: Ch 1, turn,

 1 Sc in first 28 Sts,

 * 2 Sc in next St,

 1 Sc in next 4 Sts, repeat from * 6 times,

 1 Sc in Center St, carry marker,

 * 1 Sc in next 4 Sts,

 2 Sc in next St,

Repeat from * 6 times,

1 Sc in last 28 Sts. 165 Sts

Rows 54-55-56: Ch 1, turn,

1 Sc in each St across row,

Carry marker.

Row 57: Ch 1, turn,

1 Sc in first 28 Sts,

*2 Sc in next St,

1 Sc in next 5 Sts, repeat from * 6 times,

1 Sc in Center St, carry marker,

* 1 Sc in next 5 Sts,

2 Sc in next St,

Repeat from * 6 times,

1 Sc in last 28 Sts. 177 Sts

Rows 58-59-60: Ch 1, turn,

1 Sc in each St across row,

Carry marker.

Finishing Row

Row 1: Ch 1, do not turn,

1 Sc in each end row St across to next,

End row, skipping the Center St.

Break off, weave in loose ends. Remove all pins.

Row 2: Ch 1, work reverse Sc around outside of Half Circle, and across end row Sts , join.

Break off, weave in loose ends.

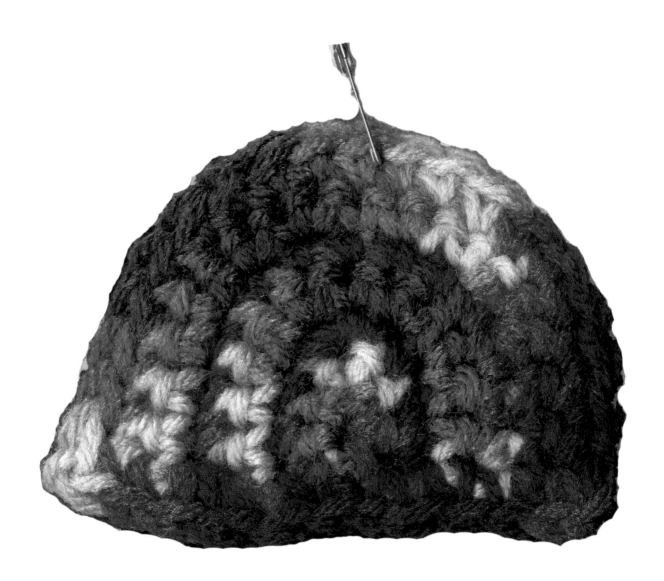

SINGLE CROCHET STITCH JOINING

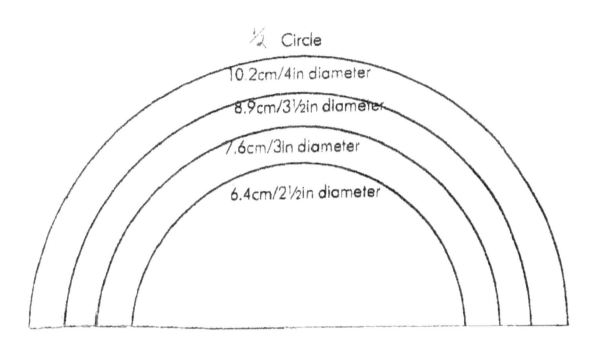

½ Circle

10.2cm/4in diameter

8.9cm/3½in diameter

7.6cm/3in diameter

6.4cm/2½in diameter

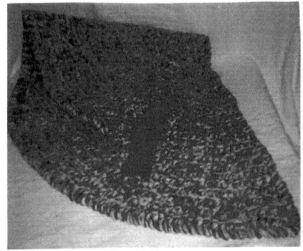

SLIP STITCH JOINING

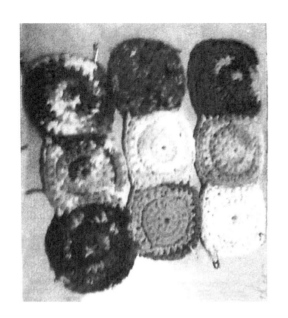
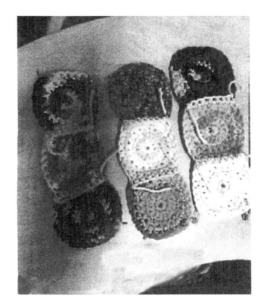

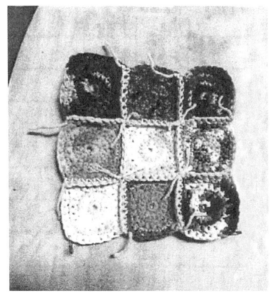

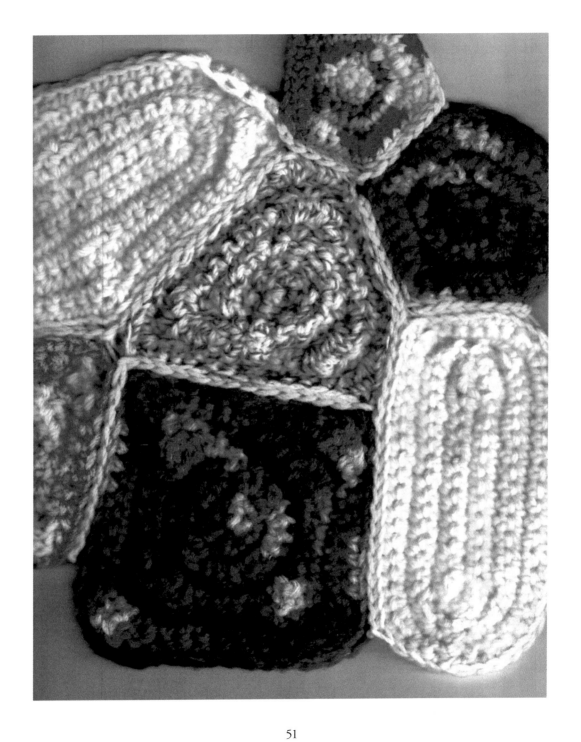

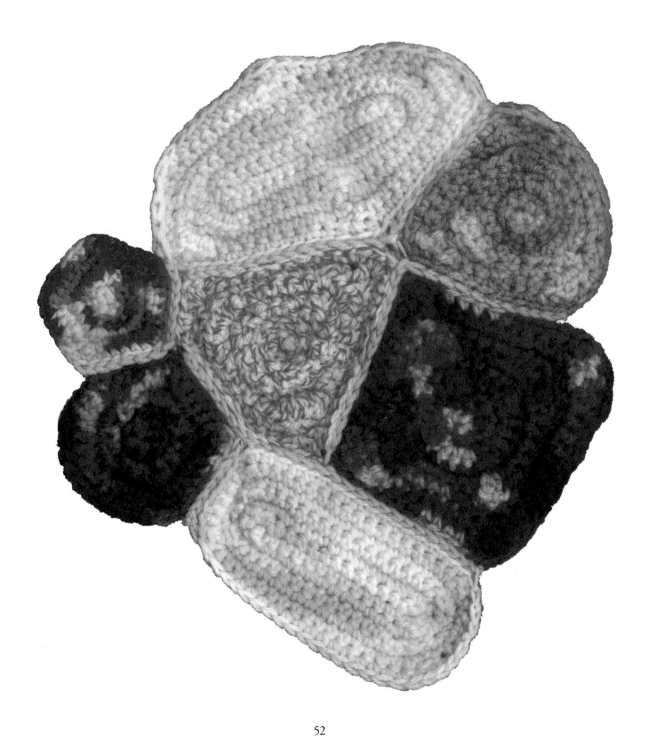

MULTI JOINING STITCH

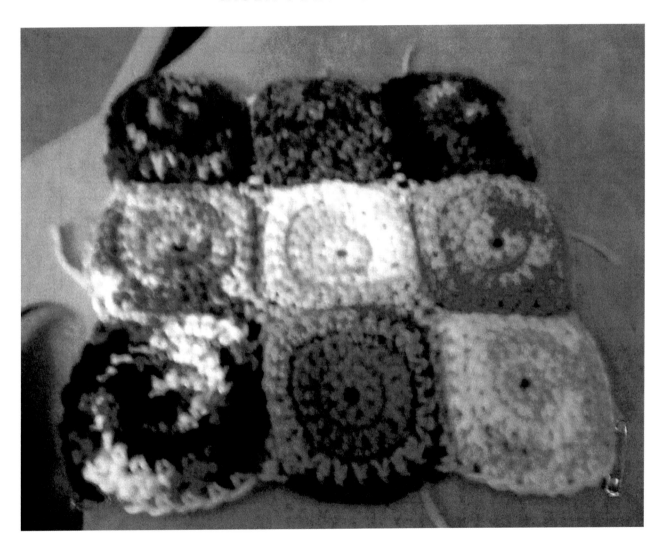

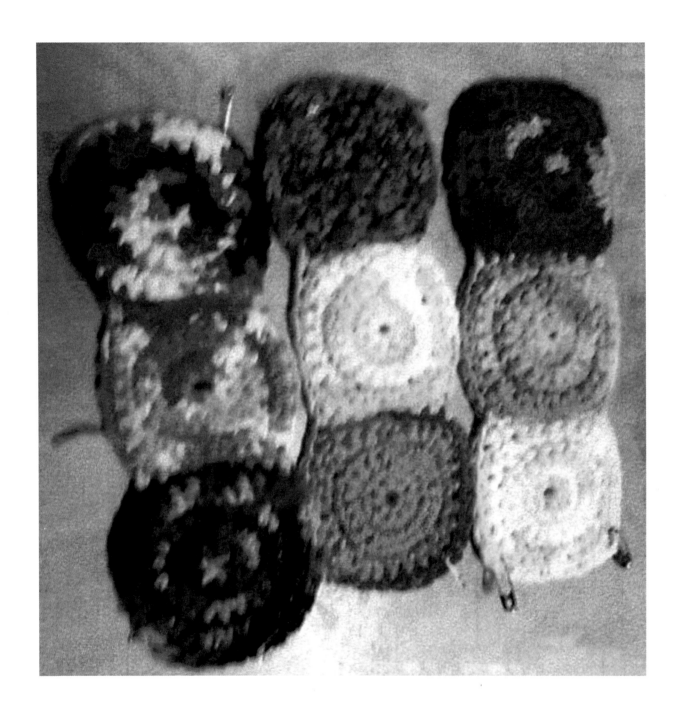

FLIP STICTH

SINGLE CROCHET STITCH

Printed in the United States
By Bookmasters